631ART.COM PRESENTS:

"IT TAKES HOLD"

A COLORING BOOK

BY EDDIE ALFARO

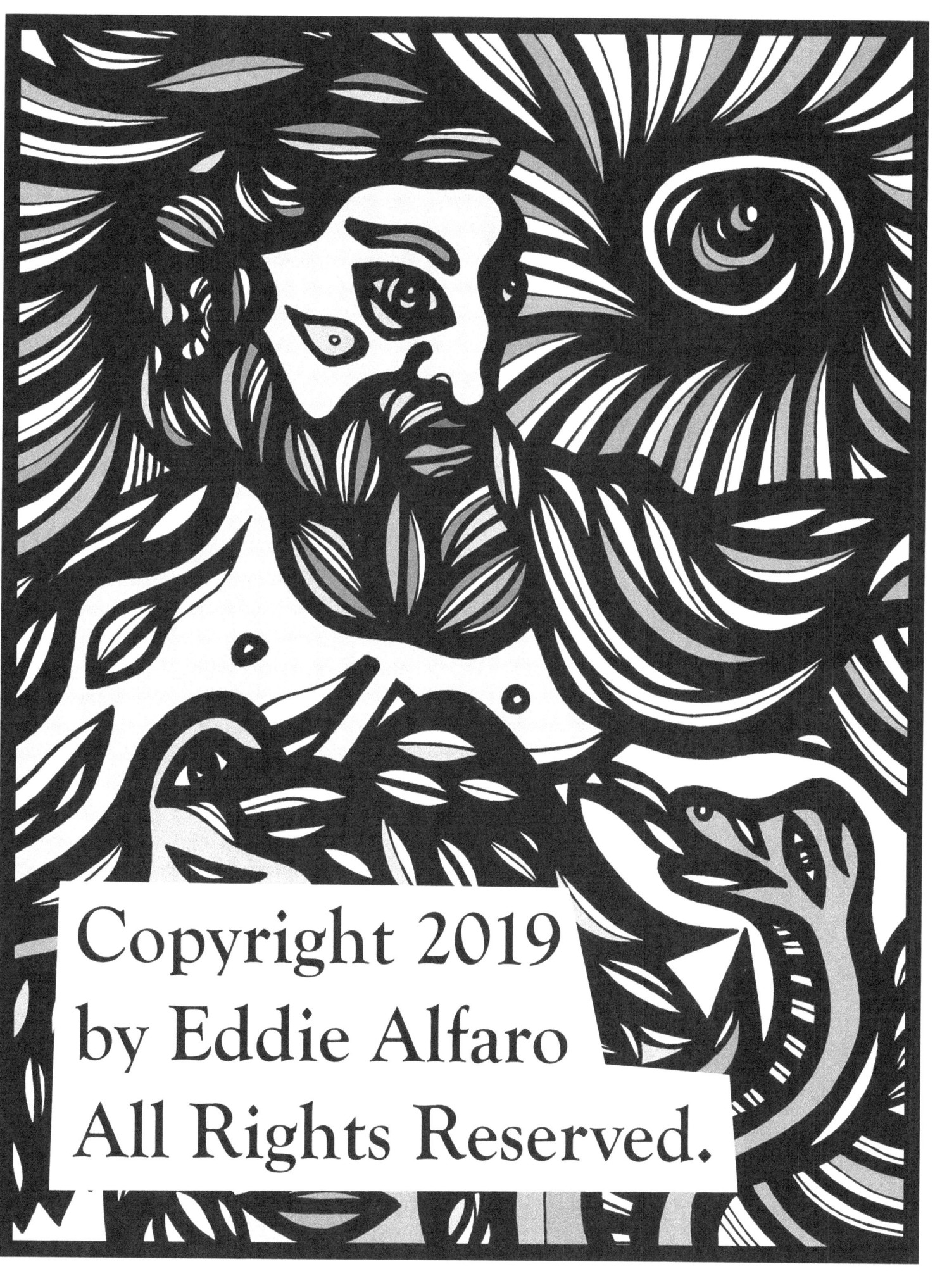

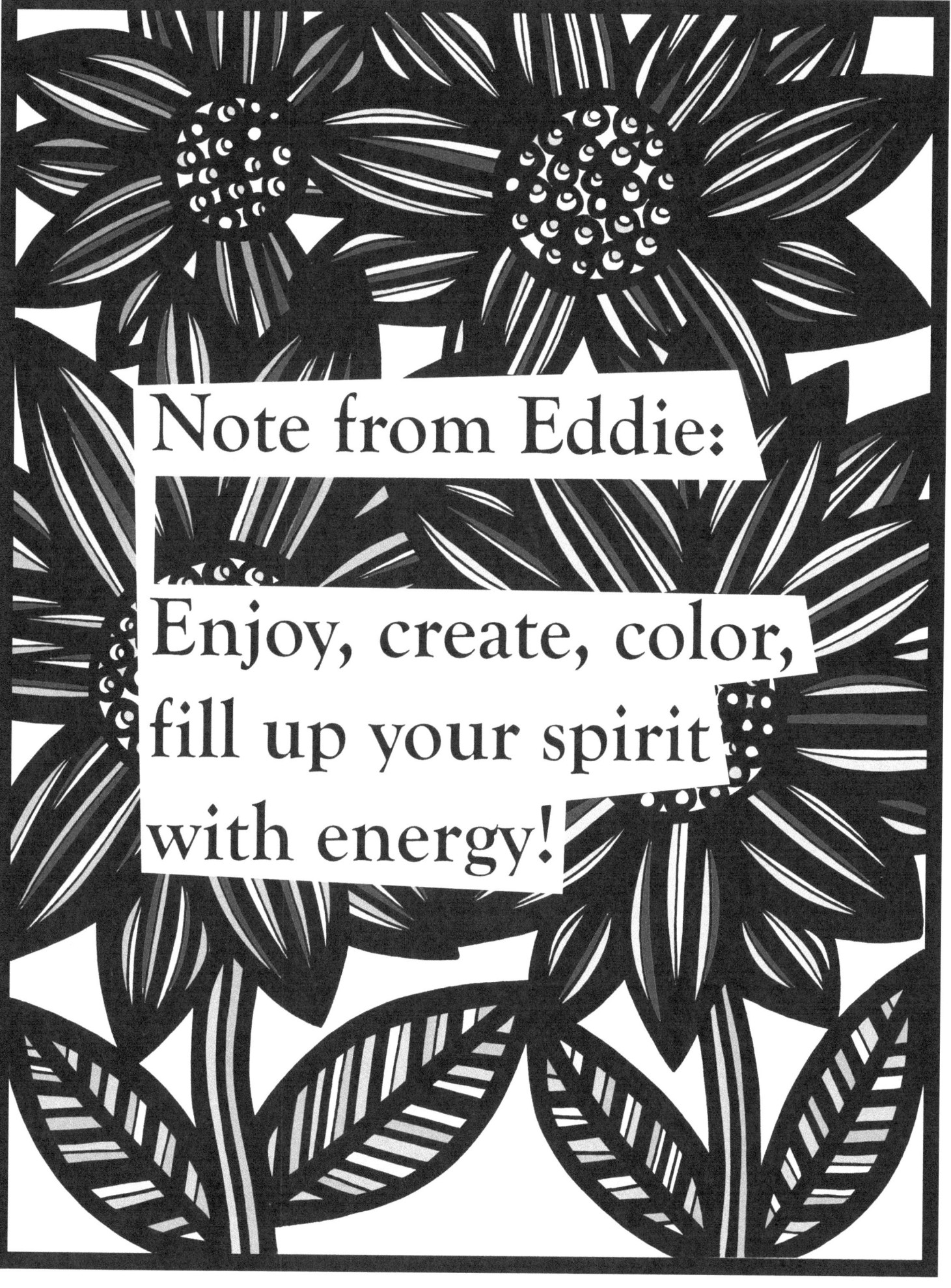

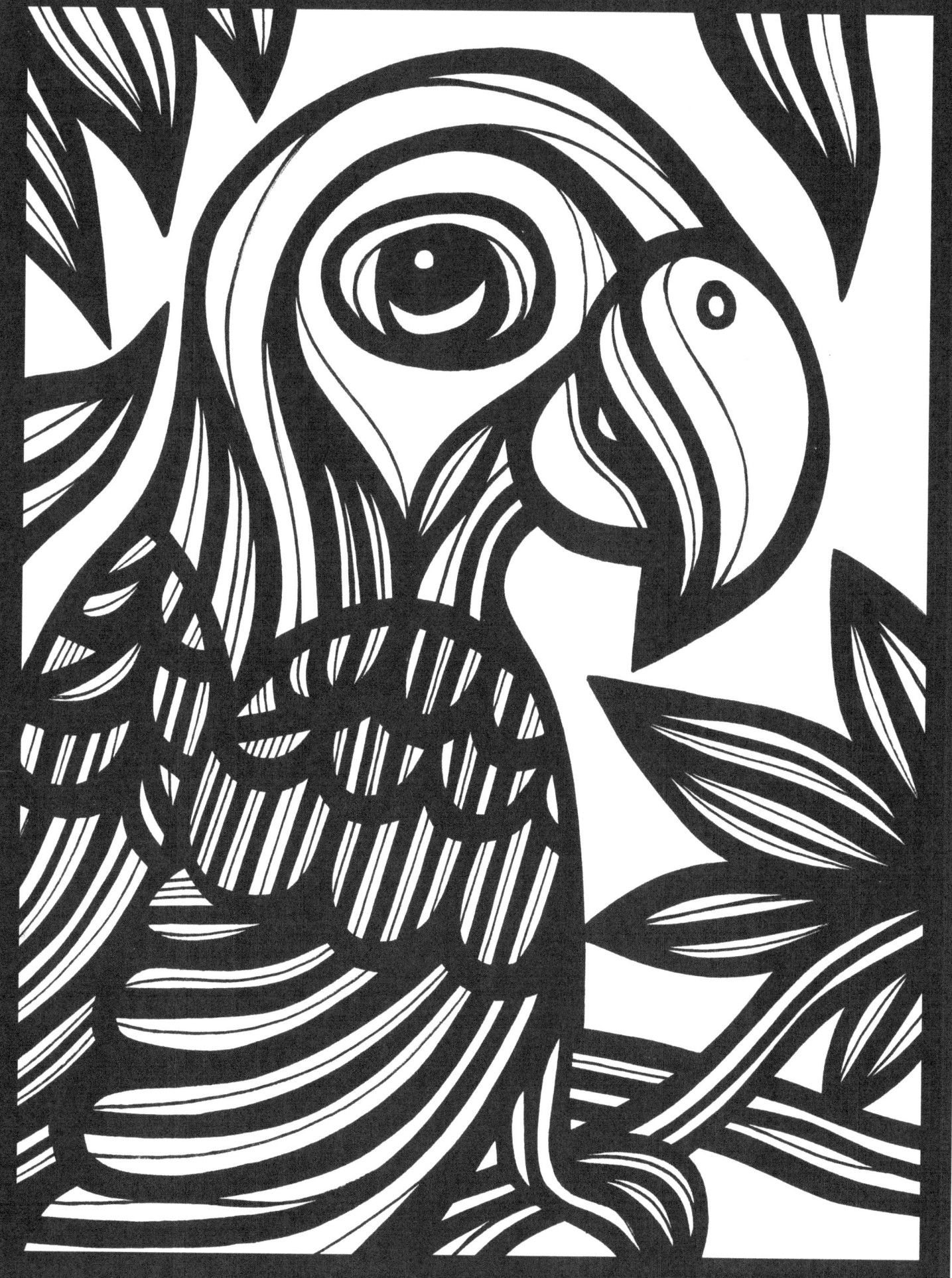

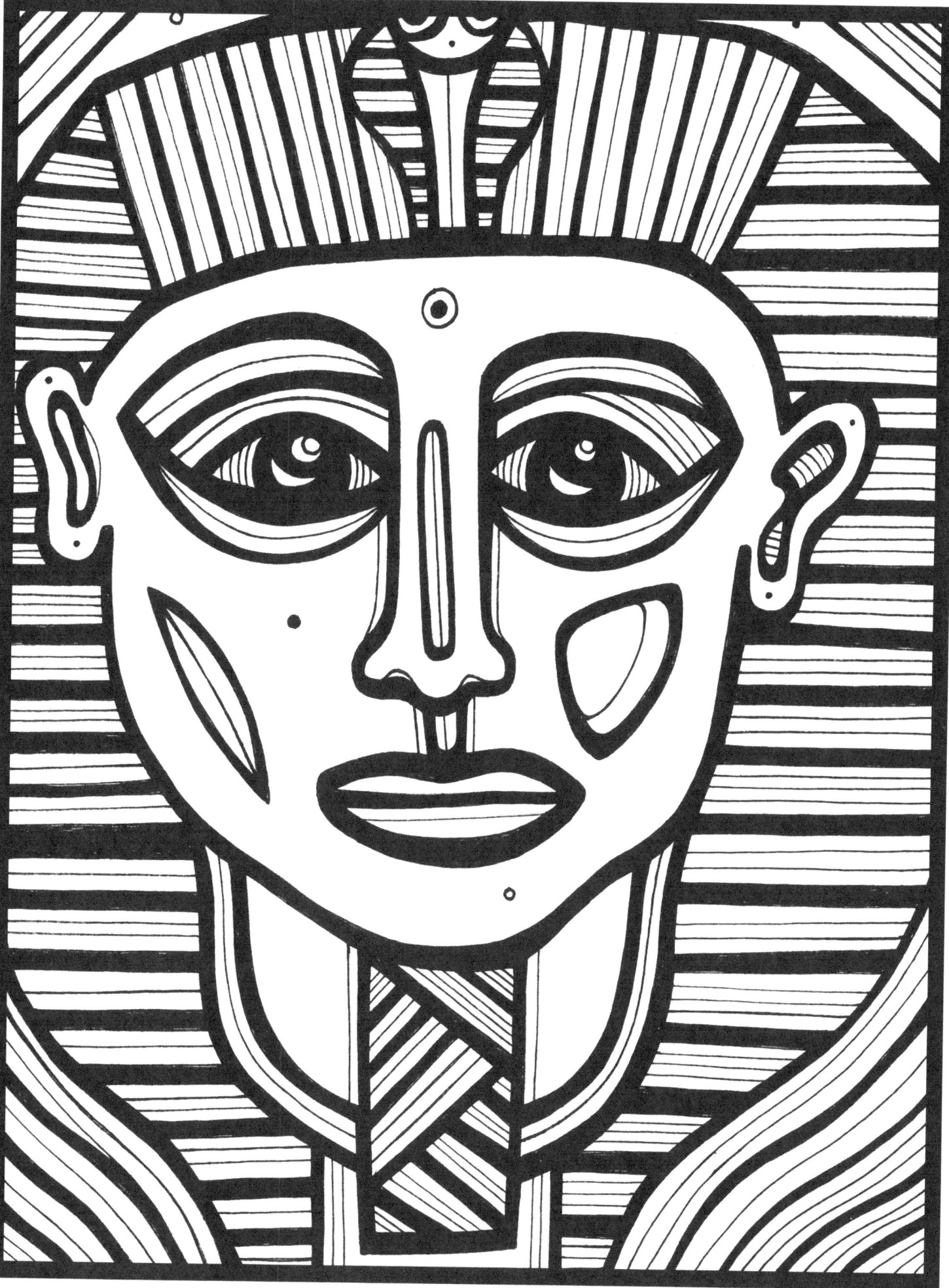

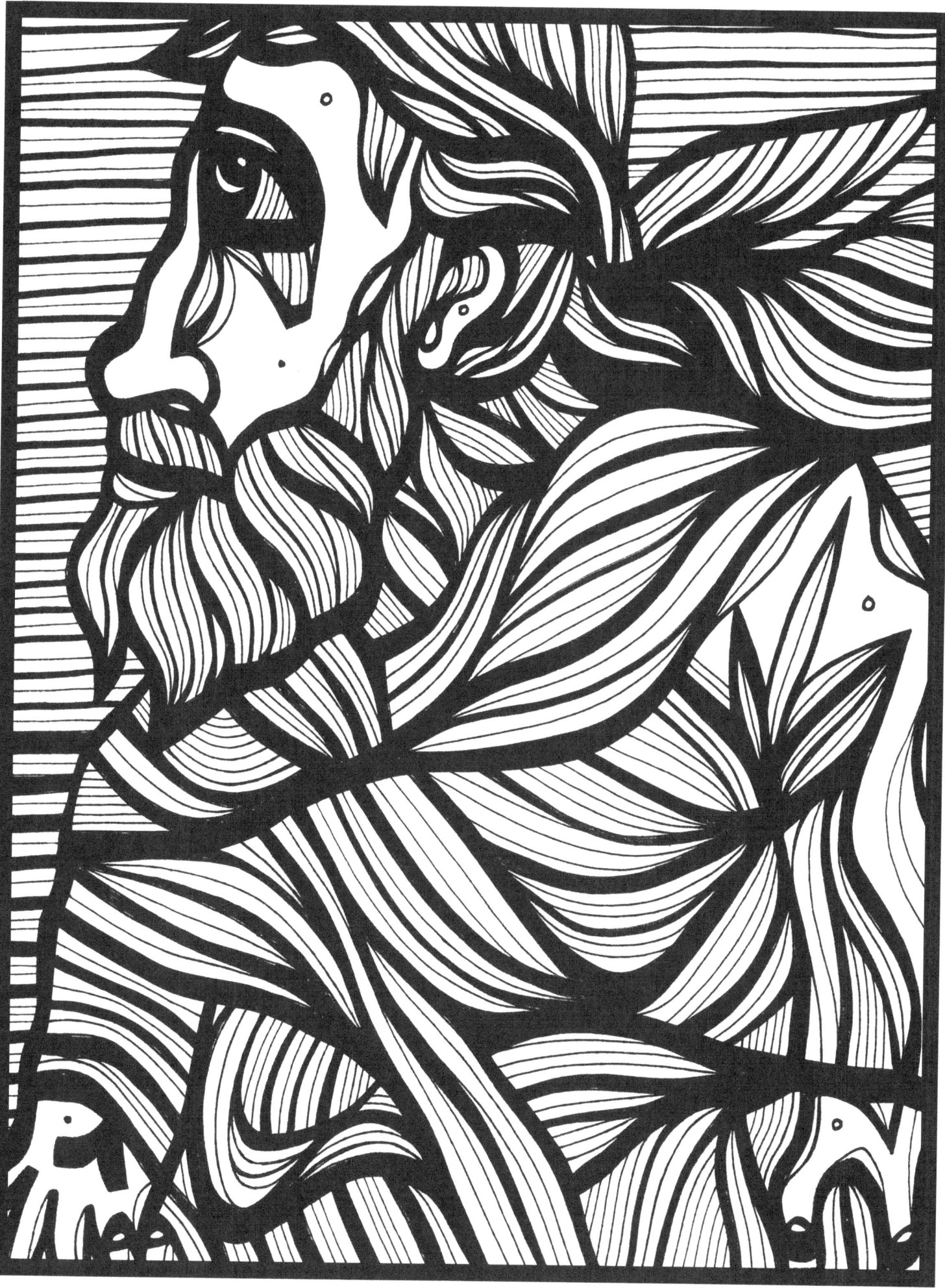

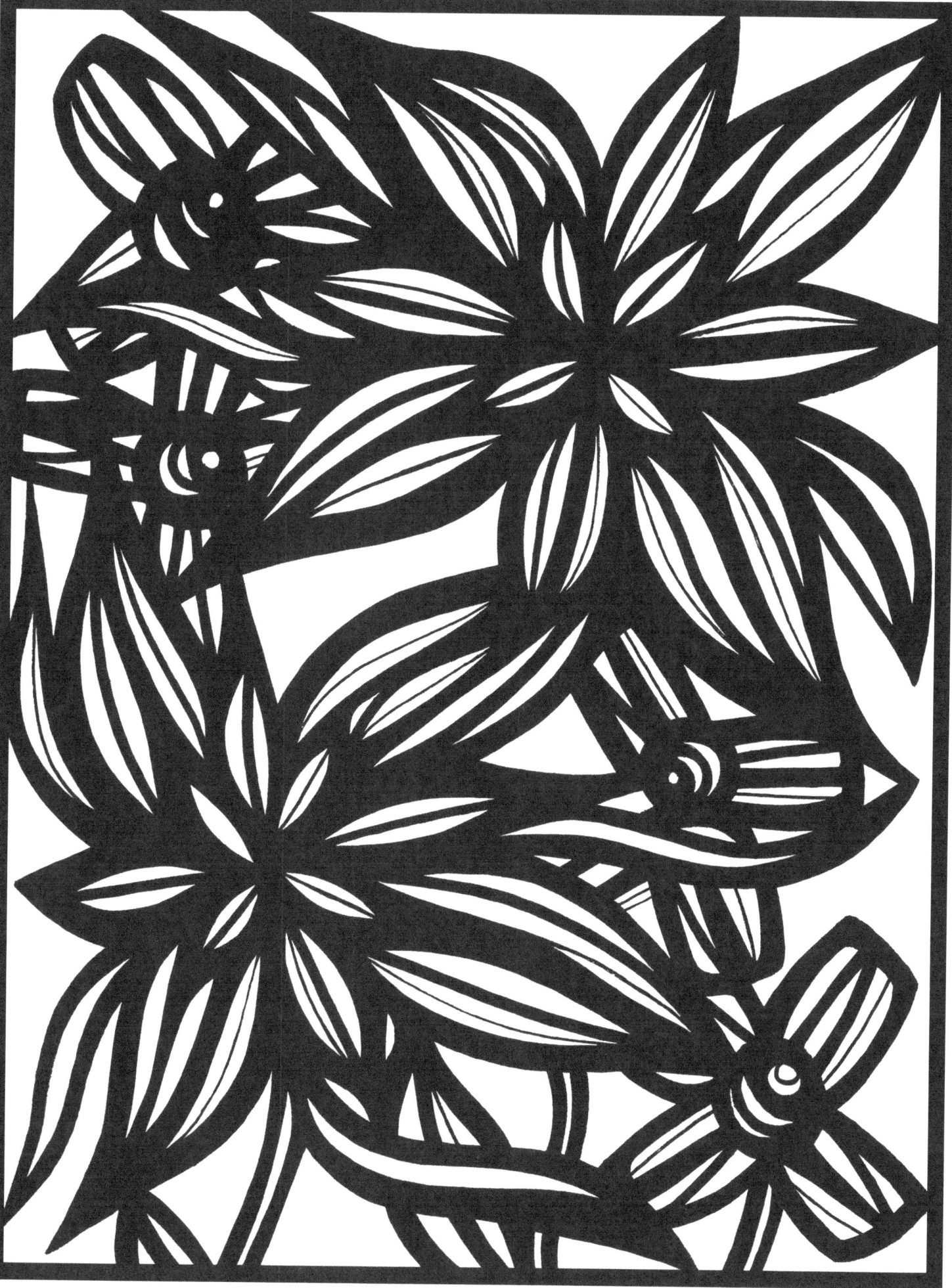

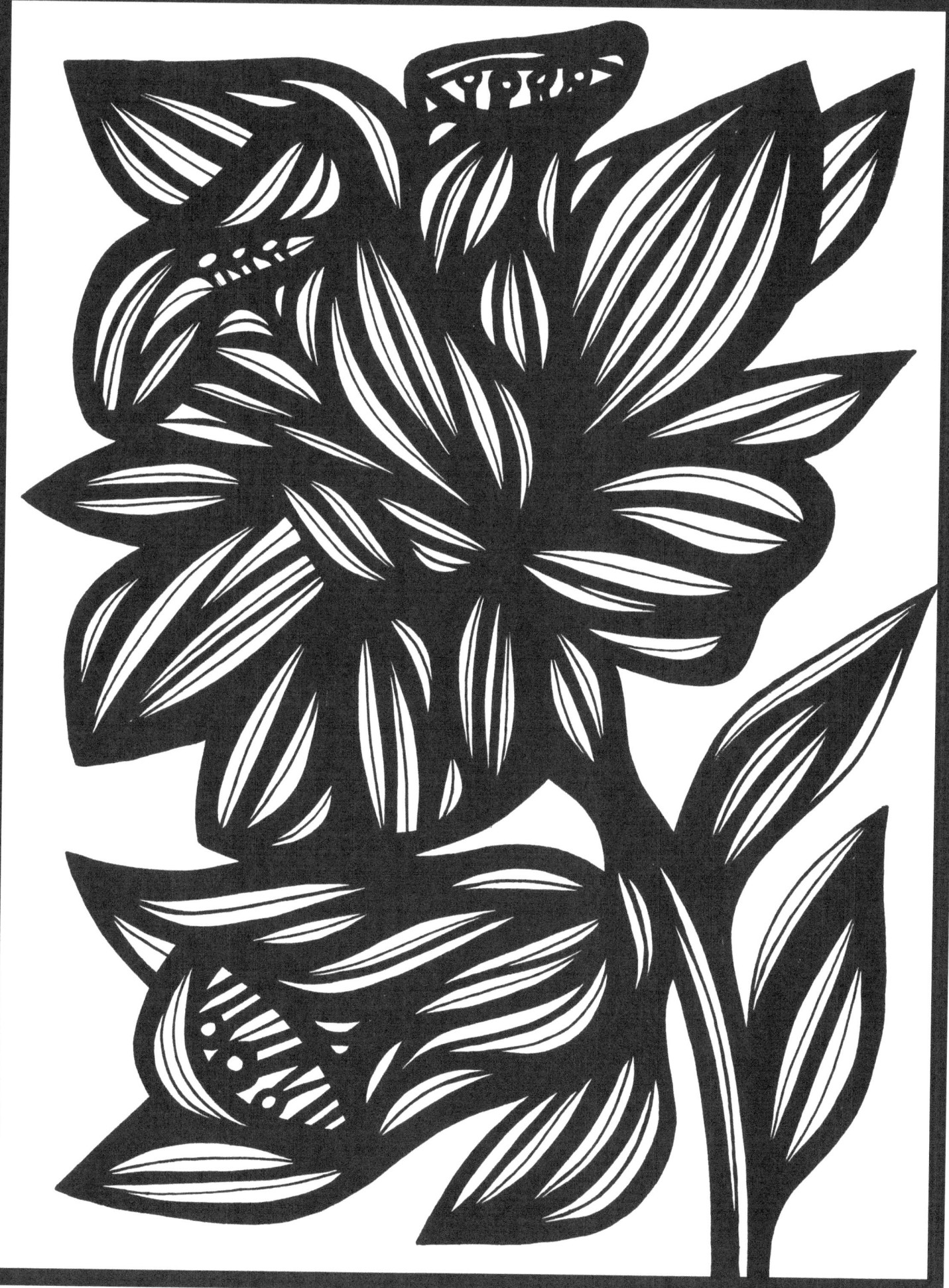

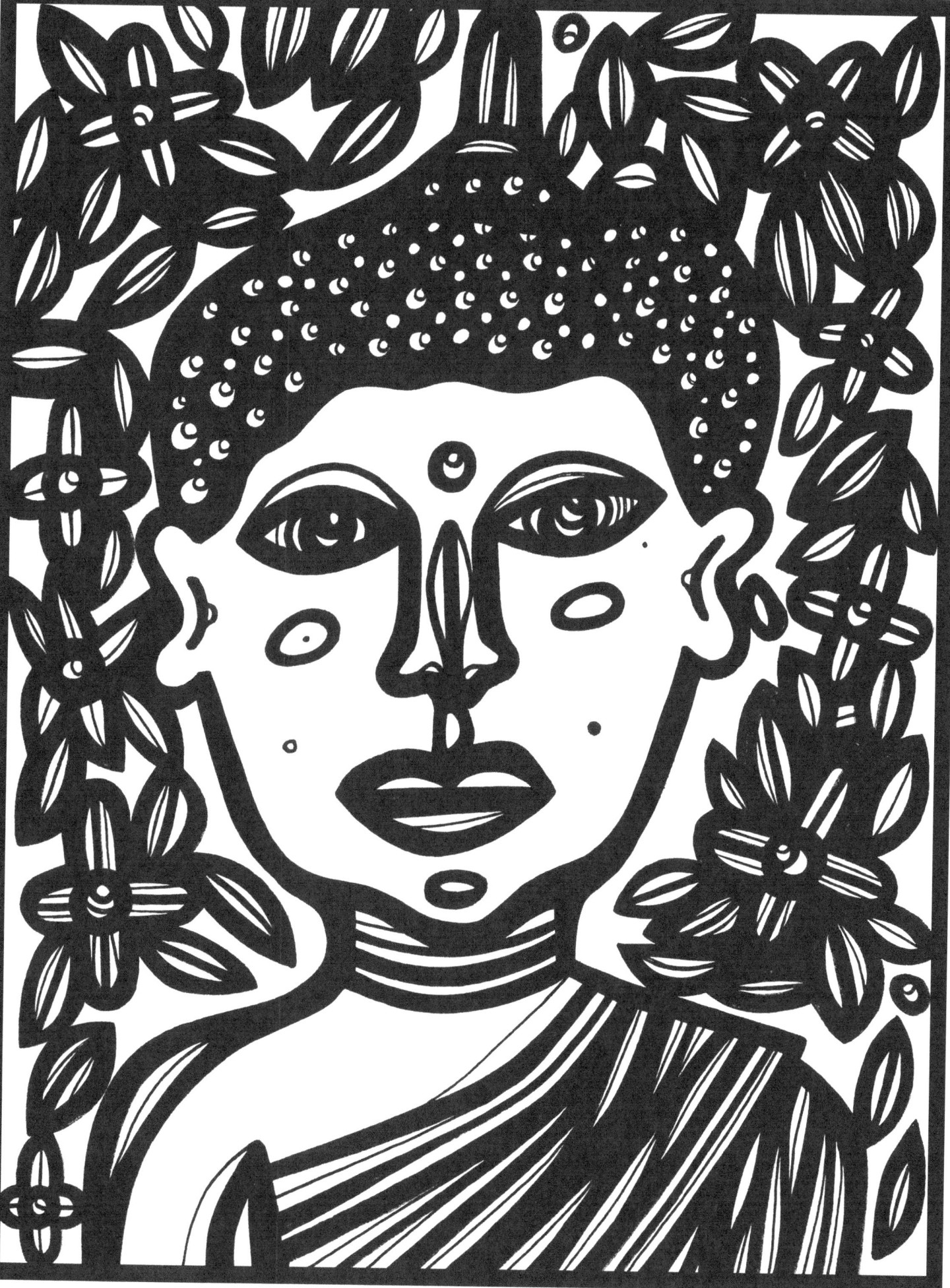

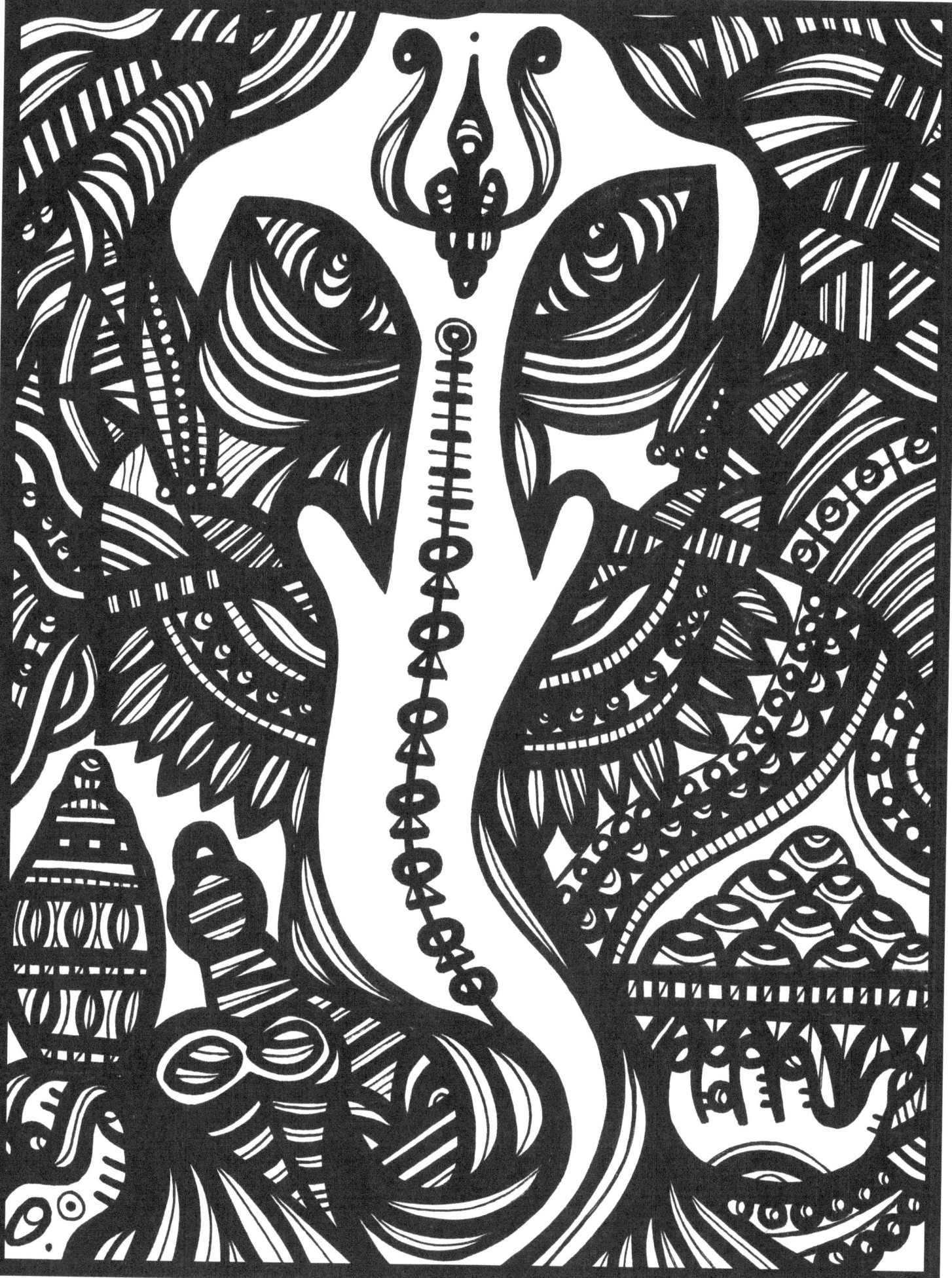

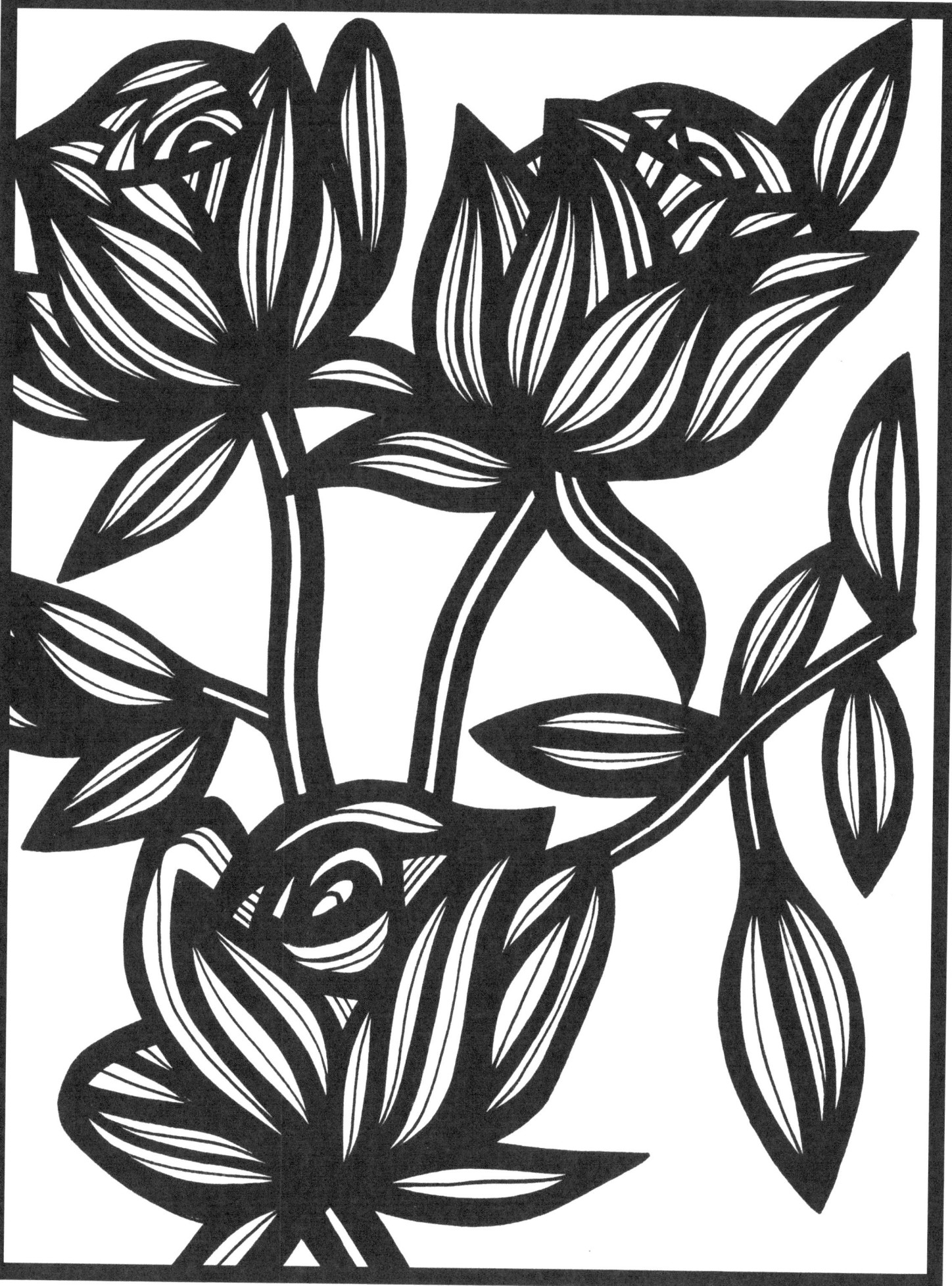

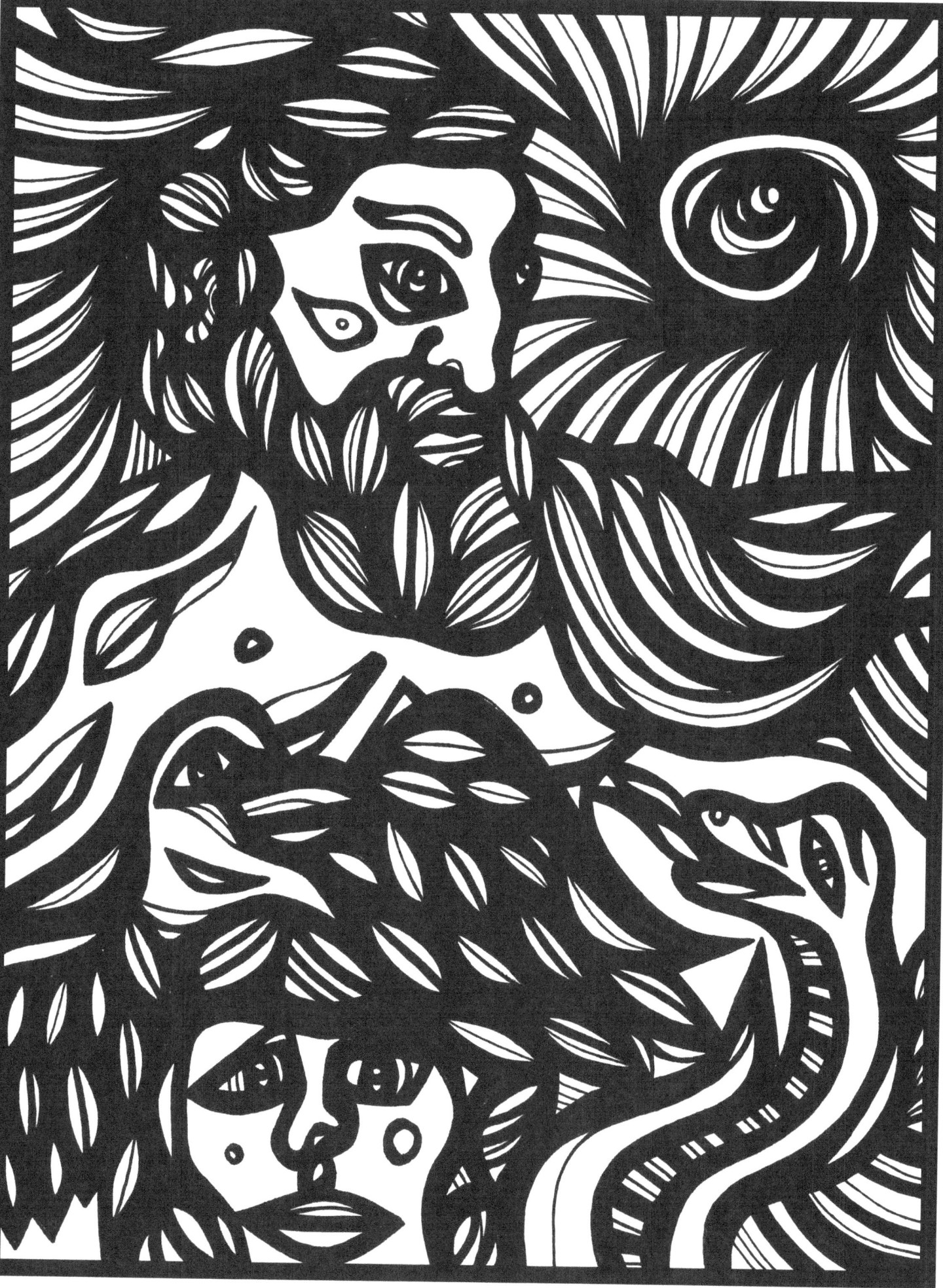

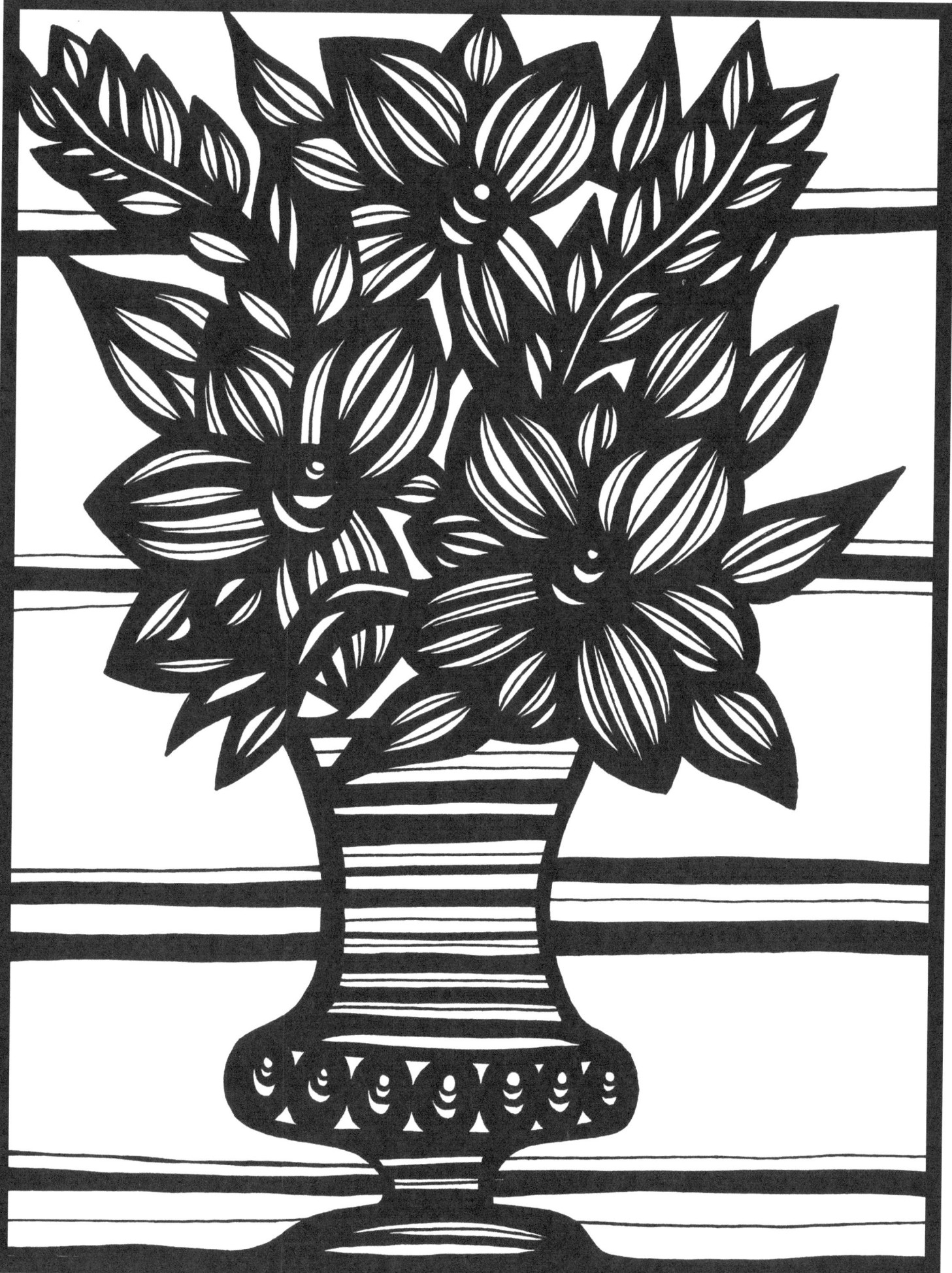

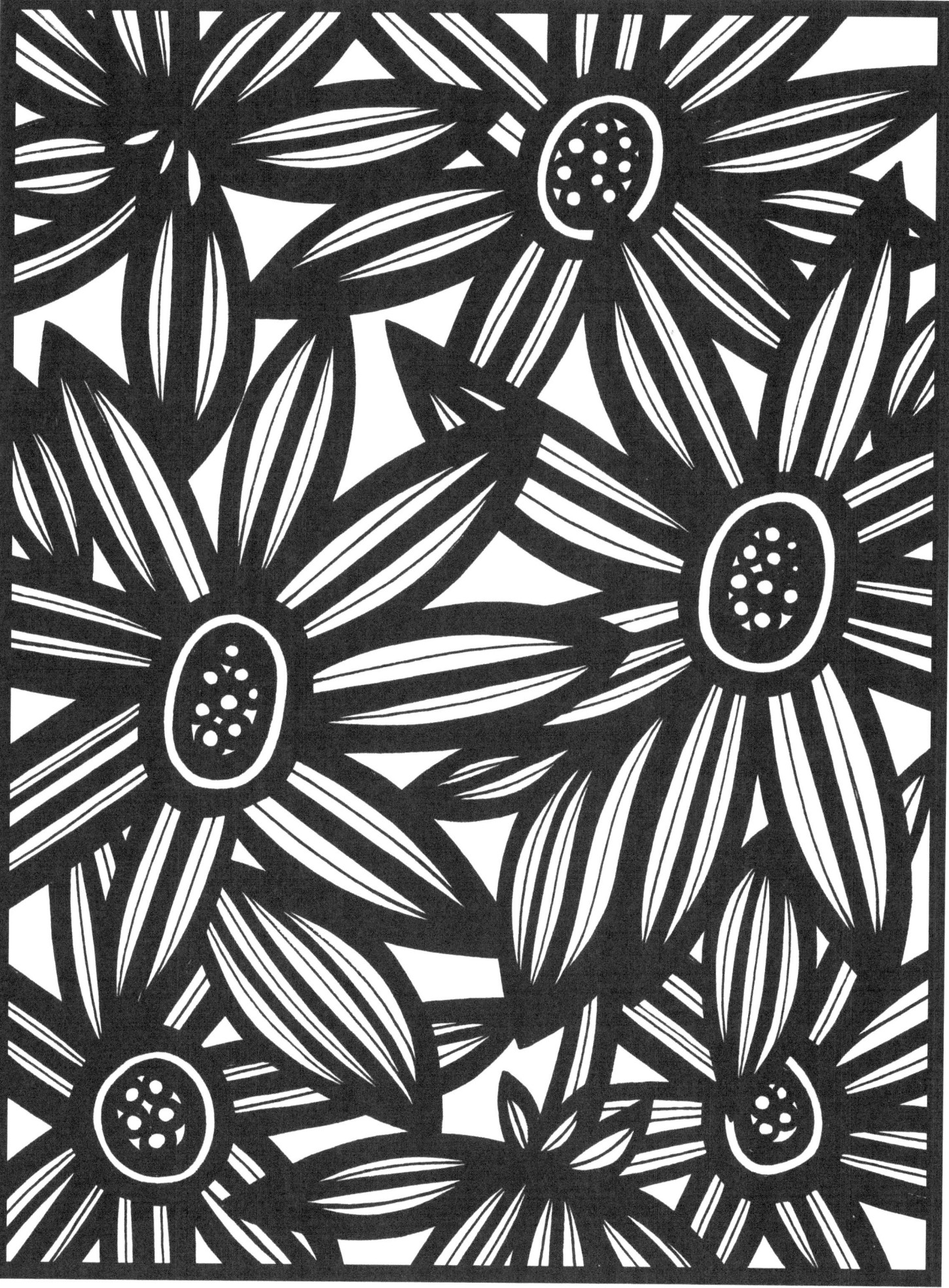

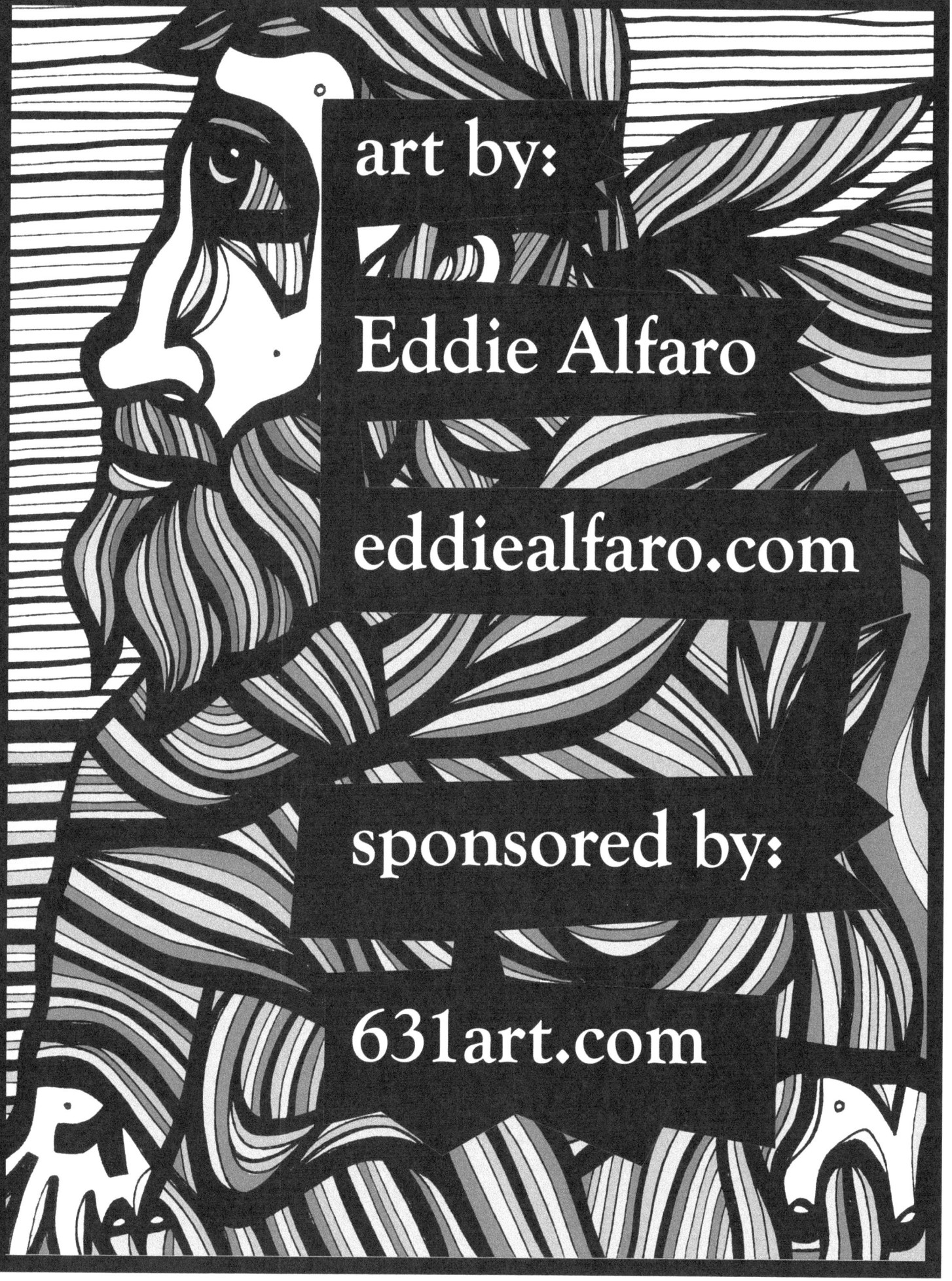

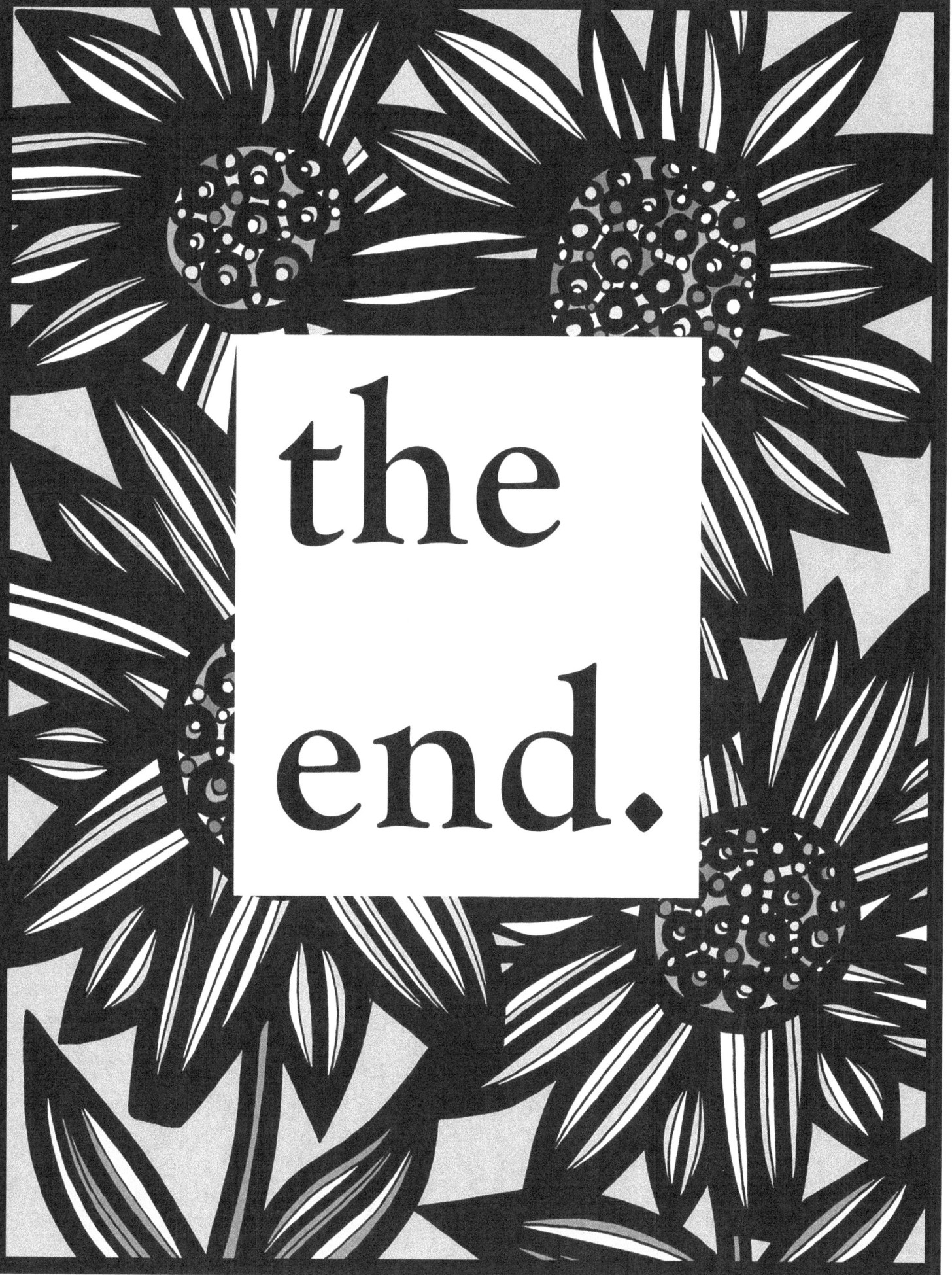

www.ingramcontent.com/pod-product-compliance
Lightning Source LLC
Chambersburg PA
CBHW080139240526
45468CB00009BA/2611